すてるデザイン

永井一史+
多摩美術大学
すてるデザインプロジェクト

持続可能な社会を
つくるアイデア

Design
for
Disposal

はじめに
Introduction

「すてるデザイン」とは、"つくる"ことで産業を支えてきたこれまでのデザインから、"すてる"を考えることで社会や産業を支えていくデザインへシフトすることを示した新しい言葉です。

現在、私たちは気候変動や資源の枯渇など、サステナビリティと向き合わなければならない時代に生きています。その中で今世界で重視されているのがゴミの問題なのです。消費したものを廃棄していたリニア（直線型）な社会から、ゴミを資源として循環させていくサーキュラー（循環型）な社会への転換です。ただ、その重要性はわかるものの、進むべき方向を見出すのは容易ではありません。多摩美術大学では、共創プロジェクト「すてるデザイン」(P184)を通じて、様々な切り口からサーキュラーな社会への手がかりを探ってきました。

デザインとは人が何を感じ、どう行動するかを考えながら、既存のやり方に捉われずに未来を模索する方法です。行政や産業界が主導し、制度や枠組みを変えていくことが必要ですが、私たち一人ひとりも考え、工夫し創造的に課題と向き合っていかなければサーキュラーな世界を実現することはできません。
本書が、デザインという切り口を通じて、みんなでサーキュラーについて考え、何らかの行動に踏み出すためのきっかけになれば幸いです。

永井一史

目次
Contents

はじめに
Introduction 2

1 ゴミ問題について知る
Question 6

2 すてるデザインの考え方
Point of View 32

3 ゴミ問題を解決する8つのREの視点
Action 44
1 : REFUSE 46
2 : RETHINK 54
3 : REDUCE 94
4 : REUSE 102
5 : REPAIR 114
6 : REPURPOSE 122
7 : RECYCLE 138
8 : REGENERATIVE 174

すてるデザイン
Design for Disposal 184

もっと知りたい方へ
Keyword 186

おわりに
Conclusion 190

1
Question

ゴミ問題に
ついて
知る

Q.1 ゴミってなんだろう? 8

Q.2 ゴミは一日にどれくらい出るの? 10

Q.3 みんな、何を捨てているの? 12

Q.4 コロナ禍で増えたゴミ、減ったゴミは何? 13

Q.5 ゴミを出さないことはできるの? 14

Q.6 家庭のゴミは捨てたらどこに行くの? 15

Q.7 プラスチックごみは、海外に輸出されているの? 16

Q.8 私たちはゴミを捨てるのに、一人いくら使っているの? 17

Q.9 食品ロスってなんだろう? 18

Q.10 賞味期限と消費期限は何が違うの? 19

Q.11 収穫された野菜の一部が畑で廃棄されているって本当? 20

Q.12 ゴミと地球温暖化は関係あるの? 21

Q.13 プラスチックって、結局何が問題なの? 22

Q.14 プラスチック問題は解決できるの? 23

Q.15 日本にはまだ埋め立てられる場所はあるの? 24

Q.16 リサイクルにはどんな種類があるの? 25

Q.17 世界でも、ゴミを燃やすことを「リサイクル」と呼ぶの? 26

Q.18 世界のリサイクル先進国はどこの国? 27

Q.19 リサイクルされた製品を選ぶにはどうしたらいいの? 28

Q.20 江戸時代はサーキュラーだったって本当? 29

Q.21 サーキュラーエコノミーってなんだろう? 30

Q.22 サーキュラーとエコノミーは両立できるの? 31

Q.1 ゴミってなんだろう？

ゴミ

waste; garbage

一般には「生活に伴って発生する不要物」を指します。
ゴミの定義は社会通念の違いで大きく変化します。かつてゴミは無価値なものと認識されていましたが、今日ではまだ使えるものが廃棄されたり、廃棄されたものが資源として再利用されるようになっており、その価値にかかわらず所有する意志を放棄したものがゴミであると考えられています。

※出典：「ブリタニカ国際大百科事典 小項目事典」(ブリタニカ・ジャパン株式会社)より。

Q.2 ゴミは一日にどれくらい出るの？

日本人が一日に排出する一般廃棄物の量は、一人あたり890グラム。日本全体で11.2万トンにもなります。
それに加え、全国の産業廃棄物の排出量は、一般廃棄物の約9倍の一日あたり102.4万トン。[※1]
一般廃棄物と産業廃棄物を合わせると、東京ドーム約3杯分[※2]ものゴミが毎日出ていることになります。
生活者がゴミを減らす行動を意識するだけでなく、企業も、資源の循環を前提とした商品設計をする、商品の耐久性を高めるなど、事業・産業の構造を変えていくことが求められています。

※1「一般廃棄 物処理事業実態調査の結果（令和3年度）」（環境省）より、令和3年度における全国のゴミ総排出量は4,095万トン。「産業廃棄物の排出及び処理状況等（令和2年度実績）」（環境省）より、全国の産業廃棄物の総排出量（令和2年度）は3億7,382万トン。
※2 ゴミの比重を0.3t/㎥として算出。（東京ドーム地上部の容積：約1,240,000㎥）

Q.3 みんな、何を捨てているの？

粗大ごみを除く家庭ごみのうち、重さで見ると、紙類と生ごみがそれぞれ約30％、プラスチック類が約10％で、この3種類で家庭ごみの約70％を占めています。

一方、大きさで見ると、プラスチック類だけで50％を超え、その多くはパック、カップ、弁当容器、袋などの容器包装です。

またこの他に、廃家電の量も多く、電気冷蔵庫、電気冷凍庫、テレビ、エアコン、電気洗濯機、衣類乾燥機の一年間の引き取り台数は1,526万台にも及びます。

※「容器包装廃棄物の使用・排出実態調査（令和3年度）」（環境省）、「令和3年度における家電リサイクル実績について」（環境省）より。

Q.4 コロナ禍で増えたゴミ、減ったゴミは何？

2021年8月に行われた「コロナ禍前後での家庭ごみに関する意識調査（BRITA Japan株式会社）」では、回答者の約半数がコロナ禍で家庭ごみが増えたと回答。
増加したゴミの種類としては、生ごみ、マスク、ペットボトル、段ボール、プラスチック製の食品容器が多く挙げられました。家庭ごみをどのくらい減らしたいかという質問に対しては、平均して「現在の64.8％に減らしたい」という回答結果に。一方、在宅勤務の増加で事業系ごみは大幅に減りました。おうち時間が増え、必然的に家庭ごみと向き合いゴミ問題を意識する人が増えたことは、デザインのチャンスになるのでしょうか？

Q.5 ゴミを出さないことはできるの？

ゴミをまったく出さないのは難しくても、減らすことはできます。
できるだけゴミを出さない生活の入門書『ゼロ・ウェイスト・ホーム』では、
気軽に実践できるゼロ・ウェイスト^(P188)活動として、**REFUSE**（断る）、
REDUCE（減らす）、**REUSE**（繰り返し使う）、**RECYCLE**（リサイク
ルする）、**ROT**（堆肥化）の「5R」を挙げ、効果が高い順に並んでいると
しています。
つまり、リサイクルに頼るよりも、そもそもゴミになるものを買ったりもらっ
たりしないことが大切ということです。

※『ゼロ・ウェイスト・ホーム ─ごみを出さないシンプルな暮らし』（ベア・ジョンソン著、服部雄
一郎訳／アノニマ・スタジオ）

Q.6 家庭のゴミは捨てたらどこに行くの？

日本の一般的な自治体では、「可燃ごみ」は収集後、焼却炉で燃やされ、最終処分場で埋め立てられます。

国土の広い北米などの国では集めたゴミの半分以上をそのまま埋め立てています[※1]が、国土面積が狭い日本では、ゴミを燃やすことで埋め立て量を減らしています。焼却では温室効果ガスが発生するため、気候変動の原因となり地球環境に様々な影響を与えています。

また、最終処分場の残余容量は減少傾向が続いており、残余年数が全国平均で23.5年[※2]となるなど、将来のゴミ処理のひっ迫が懸念されています。

※1「What a Waste 2.0」（世界銀行）より。
※2「一般廃棄物処理事業実態調査の結果（令和3年度）について」（環境省）より。

Q.7 プラスチックごみは、海外に輸出されているの？

日本を含め先進国は、2000年頃から多くのプラスチックごみを「資源」という名目で海外に輸出してきました。

受け入れ先となってきたのは中国です。その中国が国内の環境汚染を理由に2017年からプラスチックごみの輸入制限を開始したため、輸出先は東南アジアへとシフトしました。しかし、その先々でも環境汚染を引き起こしていることが指摘され、「私たちの国は、先進国のゴミ捨て場ではない」として各国が輸入規制を始めました。さらに、2021年には「バーゼル条約」附属書の改正でプラスチックごみ輸出の規制が国際的に強化されました。先進国は国内での処理体制を早急に整える必要がありますが、インフラが整わず、行き場をなくしたプラスチックごみが不法輸出されるという問題も起きています。

Q.8 私たちはゴミを捨てるのに、一人いくら使っているの？

ゴミ処理事業経費は年間2兆1,449億円で、国民一人あたりに換算すると17,000円となります（2021年度）。
そのうち約45％が中間処理（焼却・分別など）にかかる費用、約40％が収集運搬にかかる費用となっています。[※1]
リサイクル率日本トップクラスの鹿児島県大崎町では、住民一人あたりのゴミ処理事業にかかる費用が全国平均の半額以下となっており、年間で節約できた1億円をまちの福祉や教育などの分野に役立てています。[※2]

※1「一般廃棄物処理事業実態調査の結果（令和３年度）」（環境省）より。
※2「大崎町　ごみ分別の手引き 令和２年度４月版」より。

Q.9 食品ロスってなんだろう？

「食品ロス」とは、本来は食べられる部分なのに捨ててしまったもののことです。家庭やレストランでの食べ残しに加え、使い切れずに捨ててしまった食材や、売れ残った食品が含まれます。

日本では国民一人あたり、お茶わん約1杯分（約113グラム）の食べ物が毎日捨てられており、それらの焼却処分による地球環境への影響や、経済損失が問題視されています。一方で、世界では飢餓に苦しむ人もいます。将来的な食料不足も懸念される中、食品の無駄をなくすことが求められています。ちなみに、「食品廃棄物」には野菜の芯や魚の骨など、食べることができない部分が含まれます。

※「我が国の食品ロスの発生量の推計値（令和2年度）」（環境省）より。

Q.10 賞味期限と消費期限は何が違うの？

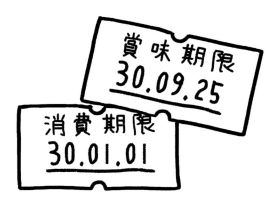

賞味期限は「おいしく食べることができる期限」。消費期限は「安全に食べられる期限」。いずれも、「書かれた保存方法を守って保存していた場合」が条件です。

消費期限はいたみやすい食品に表示されており、消費期限を過ぎた食品を食べることには健康上のリスクがあります。一方で、賞味期限は比較的いたみにくい食品に表示されており、期限を過ぎてもすぐに食べられなくなるとは限りません。しかし、いずれの期限も「その日を過ぎたら捨てるもの」と認識している消費者が多いことも事実です。

Q.11 収穫された野菜の一部が
畑で廃棄されているって本当？

畑で収穫される農作物の約14％は、出荷されずに処分されています。その原因には、需給バランスの調整に加え、「規格」の存在があります。規格は形の大小や形状、傷の有無などによって決められており、例えば曲がりすぎているきゅうりや、いびつな形のトマトが、規格外野菜として捨てられています。

また、2020年に国内で初めて感染者が確認された新型コロナウイルスの感染拡大の影響で、休校や飲食店の休業・時短営業により野菜の需要が一気に縮小した際は、農家は出荷調整を行わざるをえませんでした。産地において廃棄されたものは、政府の統計上の食品ロスには反映されていません。

※「令和2年産野菜生産出荷統計」（農林水産省）より。

Q.12 ゴミと地球温暖化は関係あるの？

廃棄物処理は地球環境に大きく影響を与えています。

日本の廃棄物処理において、代表的な温室効果ガスであるCO_2の排出量は総排出量の約3％ですが、CO_2の約25倍の温室効果を持つメタンの排出量は総排出量の約12％、CO_2の約300倍もの温室効果を持つ一酸化二窒素は総排出量の約20％を占めています。CO_2は主にゴミの焼却や運搬工程で、メタンは埋め立てや排水処理で、一酸化二窒素は排水処理や焼却で発生しています。

モノをつくったり買ったりする際には、廃棄されるまでのカーボンフットプリント[P186]に目を向ける必要があります。

※「2021年度（令和3年度）の温室効果ガス排出・吸収量（確報値）について」（環境省）より。

Q.13 プラスチックって、結局何が問題なの？

プラスチックの問題は大きく分けて2つ、「生態系や人体への影響」そして「地球温暖化の加速」です。
プラスチックは様々な要因で自然界に流れ出しますが、分解されず残り続けることで、生態系や人体に影響を与える可能性があります。石油由来のプラスチックについては、製造や廃棄の過程でCO_2が排出されます。そのため、私たちがプラスチックを使い続けることは、地球温暖化の加速につながってしまうのです。

Q.14 プラスチック問題は 解決できるの？

　微生物の働きで最終的に水とCO_2に分解される「生分解性プラスチック」
(P188)は、プラスチック問題解決の切り札の一つとして期待されています。
しかし、生分解性であっても水の中では分解されにくいものが多いこと、
石油由来であれば分解されたとしても地球温暖化を助長してしまうことな
ど、様々な課題があります。現在使用しているプラスチックを生分解性プ
ラスチックに置き換えるだけではなく、プラスチックの使用量を減らすこと、
プラスチックのリサイクル率を高めることを含めて、包括的に考えなければ
プラスチック問題は解決できません。

Q.15 日本にはまだ埋め立てられる場所はあるの？

現在も最終処分場の新設を行っている自治体もありますが、土地の確保や周辺住民の理解を得ることはとても大変です。

そのため、すでに埋め立てた焼却灰を掘り起こして現在の技術で減量化するなどして、最終処分場の延命をはかっている自治体もあります。なお、東京23区のゴミは東京湾に埋め立てられていますが、東京港内に現在使用している新海面処分場の次に処分場を設置できる水面はなく、これが東京23区最後の最終処分場となっています。現在の捨てる仕組みを、当たり前に続けることはできないのです。

Q.16 リサイクルにはどんな種類があるの？

原料として再資源化する「マテリアルリサイクル」と、化学的に分解し原料として再利用する「ケミカルリサイクル」があります。
「マテリアルリサイクル」はさらに、同一製品の原料に使用する「レベルマテリアルリサイクル」と、一段階下げた分野の製品原料に使用する「ダウンマテリアルリサイクル」に分けられます。不要になったものをそのままの形で使う「リユース」や、素材をそのまま生かして新たな製品としてアップグレードさせる「アップサイクル」は、リサイクルとは区別されています。

Q.17 世界でも、ゴミを燃やすことを「リサイクル」と呼ぶの？

日本だけです。日本では、ゴミを燃やす際に発生する熱をエネルギーとして使う「サーマルリサイクル」が、プラスチックのリサイクルの62%^{（※）}を占めています。

しかしサーマルリサイクルは日本独自の用語で、海外ではエネルギー回収と呼ばれ、リサイクルとは見なされていません。

サーマルリサイクルにも低コストで様々な廃棄物を活用できるなどのメリットはありますが、一回限りの活用となり、資源を有効に活用しているとはいえないのです。

※「プラスチックリサイクルの基礎知識2022」（一般社団法人プラスチック循環利用協会）より。

Q.18　世界のリサイクル先進国はどこの国？

リサイクル率1位はスロベニア（71.7％）、2位はドイツ（66.7％）、3位は韓国（59.7％）です。[※1]
三ヵ国とも食品廃棄物を分別回収していることが特徴で、韓国では生ごみの分別処理と従量課金制の導入（2013年）により、食品廃棄物のリサイクル率が95％[※2]となっています。回収した食品廃棄物は堆肥や飼料にリサイクルされますが、リサイクルされた堆肥や飼料の受け取り手が少ないという課題も生じています。一方、日本のリサイクル率は19.9％[※3]に留まっています。日本のリサイクル率を上げるには、食品廃棄物の処理のあり方をどう変えていくかという視点が欠かせません。

※1「Environment at a Glance - OECD Indicators」より、2019年の一般廃棄物の処理方法のうち、リサイクルとコンポストを合わせた割合。
※2「South Korea once recycled 2% of its food waste. Now it recycles 95%」（World Economic Forum）より。
※3「一般廃棄物処理事業実態調査の結果（令和3年度）について」（環境省）より。

Q.19 リサイクルされた製品を選ぶには どうしたらいいの？

古紙パルプ配合率100％再生紙を使用

グリーンマーク

PET再利用品

リサイクルされた製品は、マークを目印に探すことができます。
例えば、日本国内の使用済みの指定ペットボトルを原料に利用し認定基準に適合した製品につけられる「PETボトルリサイクル推奨マーク」、古紙を規定の割合以上原料に利用した製品につけられる「グリーンマーク」、古紙パルプ配合率を示す「再生紙使用（R）マーク」などがあります。また、「Rマーク」のついているリターナブルびんは、認定規格で統一されており、返却、詰め替えをすることによって、何度も繰り返し使うことができます。

斗々屋 48

ゴミを出さないスーパーマーケット

I'm full 52

買いすぎない買い物袋をつくる

ゴミを出さない
スーパーマーケット

斗々屋｜株式会社斗々屋

斗々屋はオーガニック食材やワインなどの輸入業から始まり、2019年から小売業を立ち上げ、そして2021年には日本初のゼロ・ウェイストなスーパーマーケットを京都にオープン。モデルショップとしてゴミを出さないビジネスを実践するとともに、全国に量り売りを広めるため、個人や企業向けにオンライン講座、現場研修、コンサルティング事業も展開しています。

1　課題
ISSUE

買い物をするたびに大量の使い捨てゴミが発生。また、小売業界では食品ロスの発生がビジネスの前提になっている。

2　アイデア
IDEA

ゼロ・ウェイストなスーパーマーケットを日本で初めてオープン。ゴミを出さないビジネスモデルを実践。

3　デザイン
DESIGN

量り売りで個包装をゼロに。さらに、食品の鮮度が落ちる前に加工して、総菜やレストランメニューに活用。

4　展開
NEXT

講座や研修、農家やメーカーのネットワークにより、ゼロ・ウェイストな小売りビジネスの仕組みを広める。

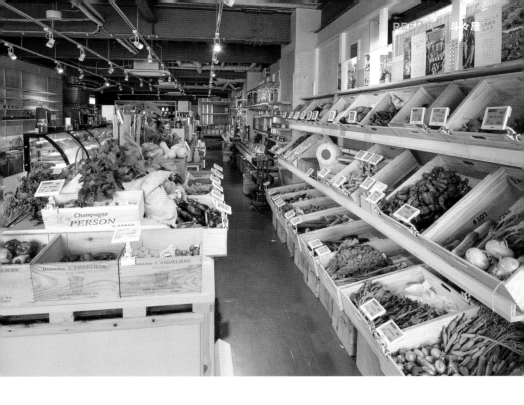

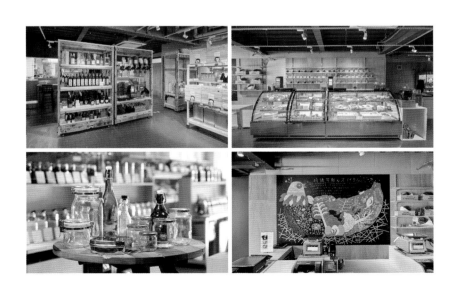

使い捨ての個包装なし、
ゼロ・ウェイストな買い物

斗々屋は、ゴミが出ない買い物ができるスーパーマーケットです。京都の店舗では、約700品目のオーガニックの生鮮食品やフェアトレードの食料品や日用品を販売しています。これらの商品には使い捨ての個包装がなく、持ち込みやデポジットを利用した容器での量り売りなどで買うことができます。
店舗では、はかりメーカーの株式会社寺岡精工と共同で開発した国内最先端の量り売りシステムを導入。売り買いの時の手数や負担を減らし、現代のライフスタイルに適した、便利な量り売りを実現させています。

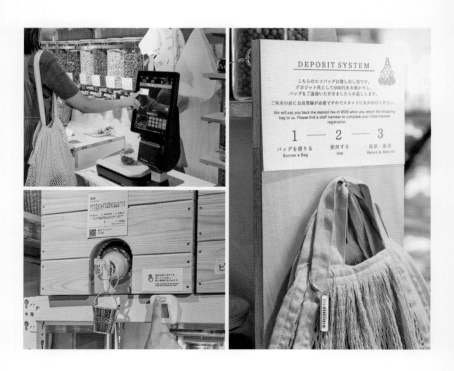

上勝町ゼロ・ウェイストセンター　　56
人口約1400人のまちの環境配慮型コミュニティスペース

きたもっく　　60
浅間北麓の地域資源を多面的に価値化する

FERMENSTATION　　64
独自の発酵技術で未利用資源を再生・循環

The Circular Design Guide　　68
誰もがアクセスできるサーキュラーエコノミーのデザインガイド

コエドブルワリー　　70
まちとともにある、クラフトマンシップを重んじる醸造所

BAUM　　74
樹木がくれる、美しい世界のはじまり

まれびとの家　　78
地域の木材×伝統×デジタルの融合

Earthship MIMA　　82
公共のインフラを必要としないオフグリッドハウス

人口約1400人の
まちの環境配慮型
コミュニティスペース

上勝町ゼロ・ウェイストセンター（WHY・ワイ）

ブランディング, クリエイティブプロダクション, エクスペリエンスデザイン, 写真：株式会社トランジットジェネラルオフィス
建築設計：中村拓志＆NAP建築設計事務所　ファニチャーデザイン：Wrap建築設計事務所
コミュニケーションライブラリー監修：BACH　事業スキームアドバイザー：株式会社トーンアンドマター
地域コーディネーター：一般社団法人 地職住進機構　運営主体：株式会社BIG EYE COMPANY

2003年に日本で初めて「ゼロ・ウェイスト宣言」を発表した徳島県上勝町で、ゴミのない
社会を目指し生産者／消費者、町民／町外在住者が交流し学び合うことを目的に2020
年5月30日「ゴミゼロの日」^(P186)にオープンした公共複合施設。

1 課題
ISSUE

ゼロ・ウェイストを目指しリサイクル率80％を達成して
いるが、20％のゴミは分別・再生ができない。社会
全体での循環型経済移行に働きかける情報発信が
必要。

2 アイデア
IDEA

ゴミの中間処理施設に加え、上勝町のゼロ・ウェイス
ト活動を魅力的に発信・体験する拠点をつくり、パー
トナーシップやイノベーションの種を育む。

3 デザイン
DESIGN

建物はほとんどゴミでできている。それ以外は、ゴミ
減量のために最低限の加工に留めた町産の杉の丸
太材の構造や板材を使用している。

4 展開
NEXT

施設のコンセプトである「WHY」を通じ、大量生産・
大量消費社会の是非を問うことから循環型社会を目
指す。産学官連携で人材の循環も生み出していきた
い。

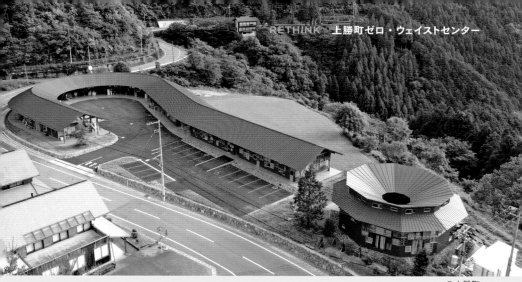

© 上勝町

上勝町ゼロ・ウェイストセンターは、ゴミの中間処理施設に町民の交流ホールやコワーキングスペース、ホテルなどが一つになった環境配慮型公共複合施設です。施設そのものも「ゼロ・ウェイストの理念」を体現するべく、町産の杉を切り出し、住民からは不要となった建具（窓や戸）などの提供を受け、建築されています。ホテルにはゴミバスケットが設置されており、町民と同じように45分別を体験できるなど、滞在中の生活を通じて、ゼロ・ウェイストの理念と向き合える工夫がされています。

この施設を拠点に、WHYという疑問詞をもって「なぜそれをつくるのか？　なぜそれを売るのか？」と生活者に問いかけ、互いに学び合う場をつくり、ゴミのない社会を目指します。

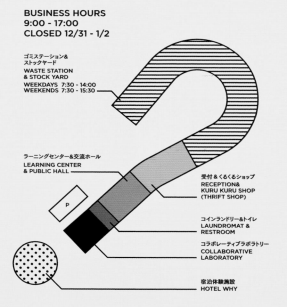

BUSINESS HOURS
9:00 - 17:00
CLOSED 12/31 - 1/2

ゴミステーション&
ストックヤード
WASTE STATION
& STOCK YARD
WEEKDAYS 7:30 - 14:00
WEEKENDS 7:30 - 15:30

ラーニングセンター&交流ホール
LEARNING CENTER
& PUBLIC HALL

P

受付&くるくるショップ
RECEPTION&
KURU KURU SHOP
(THRIFT SHOP)

コインランドリー&トイレ
LAUNDROMAT &
RESTROOM

コラボレーティブラボラトリー
COLLABORATIVE
LABORATORY

宿泊体験施設
HOTEL WHY

ゼロ・ウェイストの発信地

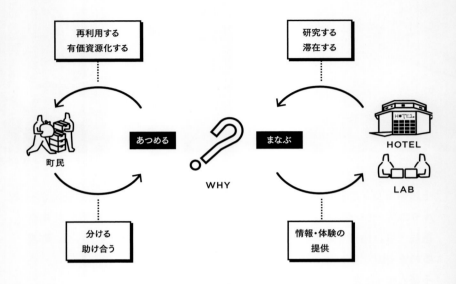

再利用する
有価資源化する

研究する
滞在する

あつめる

まなぶ

町民

WHY

HOTEL

LAB

分ける
助け合う

情報・体験の
提供

生産者と消費者がゴミから学ぶ

長年、ゴミの発生抑制と多分別・資源化を進める上勝町は、ゼロ・ウェイスト目標として「焼却・埋め立て処分をなくす」を掲げており、2020年に再宣言を行いました。達成を阻んでいる要因には、製品設計（複合素材の使用や使い捨てのデザイン）や消費方法が関係しています。例えばリサイクル技術が確立されていない素材や、リサイクルに多額のコストがかかるため、焼却・埋め立て処分されているゴミは、まだ多く存在しています。ゴミの排出量削減や資源循環を達成するには、製品設計やコスト設定の変革など、上勝町だけではなく社会全体で取り組む必要があります。上勝町ゼロ・ウェイストセンターでは、サーキュラーエコノミーのプラットフォームをつくり、体験やコラボレーションを通じて、生産者と消費者の双方にアプローチしています。

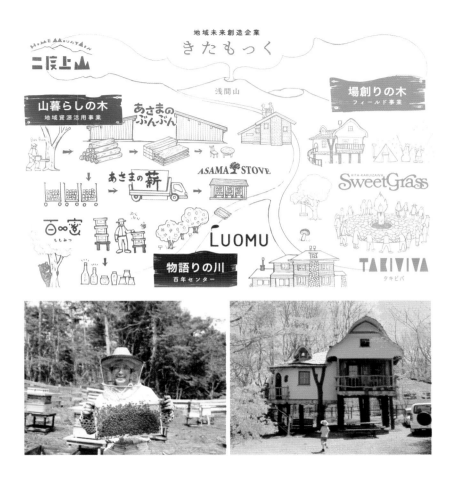

きたもっくの展開する多面的な事業は多くの雇用を生み出し、この地域に根差す人を育てています。2021年には長野原町と包括連携協定を締結し、地域内連携を本格化させました。

様々な社会課題が表面化している中山間地域だからこそ、自然と人の適切な関係づくりを通して生きることと働くことを重ね合わせ、豊かな未来の創造につなげていくことができると考え、地域の自然条件に従う新しい産業モデルの構築を目指しています。

独自の発酵技術で
未利用資源を再生・循環

FERMENSTATION
Co.,Ltd.
Fermenting a Renewable Society

FERMENSTATION｜株式会社ファーメンステーション

「Fermenting a Renewable Society」を目的に、未利用資源を再生・循環させる社会へ。独自の発酵技術で食品ロス／ウェイストおよび、その他未利用バイオマス由来のエタノールやサステナブルな化粧品原料を自社工場で開発、製造過程で生成される発酵粕は、化粧品原料や地域の鶏や牛の飼料として利用、糞は水田や畑の肥料にするなど、廃棄物ゼロの地域循環型事業を構築しています。「B Corp認証」[P189]取得。

1 課題
ISSUE

休耕田、食品・飲料工場から排出される食品由来のゴミなど、有効活用されていない「未利用資源」の存在。

2 アイデア
IDEA

独自の発酵技術を活用し、「未利用資源」を高付加価値化して商品化、循環型事業を構築。

3 デザイン
DESIGN

耕作放棄地や休耕田を活用して育てたオーガニック玄米を主力に、エタノールや化粧品原料を開発。

4 展開
NEXT

未利用資源が再生・循環する社会の構築を目指し、様々なステークホルダーと関わり続ける。

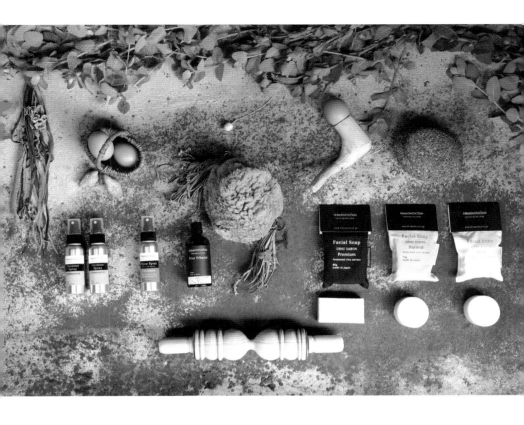

お米は世界的には貴重な資源ですが、日本では年々消費量が減り、休耕田が増えています。

FERMENSTATION は岩手県奥州市を拠点に、こうした休耕田や耕作放棄地を再生して育てたオーガニック玄米を主力に、食品・飲料工場から排出される食品残渣や規格外青果などの有効活用されていない「未利用資源」を使い、独自の発酵技術で精製、高付加価値化したエタノールや化粧品原料を開発しています。農産資源由来のトレーサブルでオーガニックのエタノールは、肌触りが優しく香りが良いのが魅力です。創業のきっかけである奥州市の田んぼを復活させ、美しい田園風景を取り戻したいという思いを胸に、新たな産業へつなげることを目指しています。

りんごとお米からエタノールをつくる
事業モデルの図

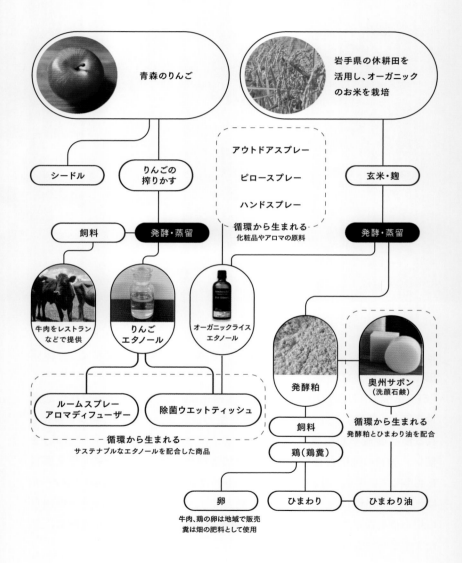

青森のりんご

岩手県の休耕田を活用し、オーガニックのお米を栽培

シードル

りんごの搾りかす

アウトドアスプレー

ピロースプレー

ハンドスプレー

循環から生まれる
化粧品やアロマの原料

玄米・麹

飼料

発酵・蒸留

発酵・蒸留

牛肉をレストランなどで提供

りんごエタノール

オーガニックライスエタノール

発酵粕

奥州サボン
(洗顔石鹸)

ルームスプレー
アロマディフューザー

除菌ウエットティッシュ

飼料

循環から生まれる
発酵粕とひまわり油を配合

循環から生まれる
サステナブルなエタノールを配合した商品

鶏(鶏糞)

卵

ひまわり

ひまわり油

牛肉、鶏の卵は地域で販売
糞は畑の肥料として使用

土地に根差す醸造所

COEDO は、ビール事業を核とした地域事業に力を入れています。コロナ禍以前は毎年、川越にて音楽イベント「コエドビール祭」を開催。「コエドビール学校」と称して、ビールの科学と文化を学ぶ醸造所見学ツアーも行ってきました。

さらに、全国的に農家の数が減り続ける中で、自らも農業の担い手になるべく、オーガニック大麦の栽培を開始。2022 年からは、麦の種まきと収穫に参加できる年 2 回の「麦ノ秋音楽祭」を醸造所敷地内にて開催。エンターテインメントの中で有機農業や生態系に自然と触れる機会を提供しています。

目指しているのは、ブルワリーのある個性あふれるまちづくり。ビールを通じて地域農業を元気にし、成果を地域に還元していこうと活動を続けています。

樹木がくれる、
美しい世界のはじまり

BAUM

BAUM

「BAUM」は、「樹木との共生」をテーマに掲げるスキンケア＆マインドブランド。「樹木がくれる、美しい世界のはじまり」をメッセージに、樹木の恵みを余すところなく受けとり、感謝し、樹木資源を未来につないでいくブランドとして、製品の90%以上を自然由来の素材で構成。2020年6月のブランド誕生以来、商品パッケージ、店頭においても"循環"を意識したサステナブルな選択をしています。

1 **課題**
ISSUE
従来のきらびやかなイメージの化粧品ではなく、プロダクトを通じて持続可能な未来を創造できるようなブランドをつくりたい。

2 **アイデア**
IDEA
自然の中で循環を繰り返す、「樹木」という存在に着目。樹木の樹皮・葉・実・根などから抽出した成分をスキンケアに配合。容器に再生可能な原料を使用し、詰め替えタイプの製品も展開。

3 **デザイン**
DESIGN
パッケージの木製パーツに、家具製造過程で出る小さな木材（端材）を使用してアップサイクル。売り上げの一部は森林の保全活動に還元し、木製パーツに使用しているオーク（ナラ）を故郷の一つである岩手県の森に、毎年600本ほど植樹する試みを実施。

4 **展開**
NEXT
個人の選択が「樹木との共生」というテーマにつながり、無理なく心地よい形で、環境保全に貢献できるような仕組みをつくる。

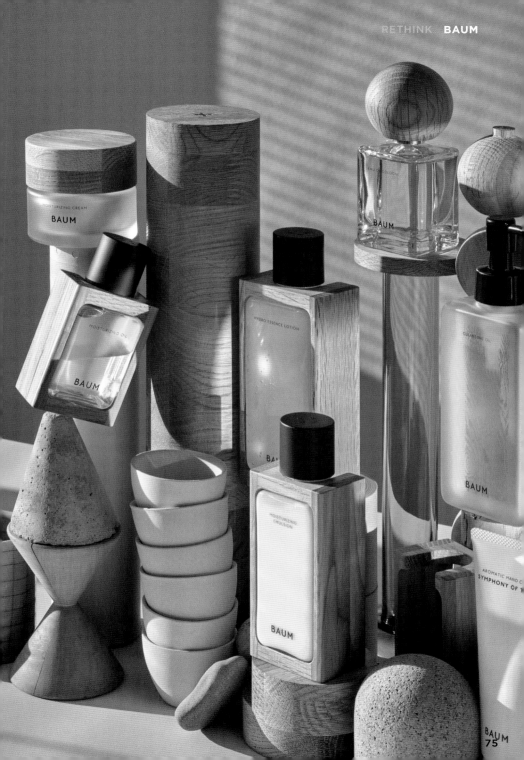

樹木の恵みを享受し、樹木資源を未来に
つなぐサステナブルな社会の実現を目指す

樹木資源を未来につなぐ活動として、BAUM は商品パッケージに木を使用しています。森林を伐採して加工するのではなく、カリモク家具株式会社とのコラボレーションにより、家具製造過程で出る小さな木材（端材）をアップサイクルして木製パーツを製作。容器にはリサイクルガラスや、一部に植物練り込み樹脂を用いるなど、環境にも優しい設計を目指しています。

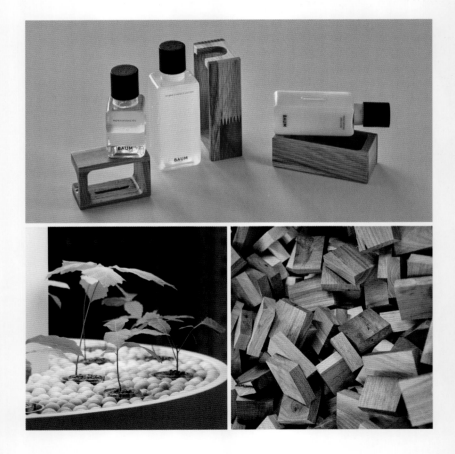

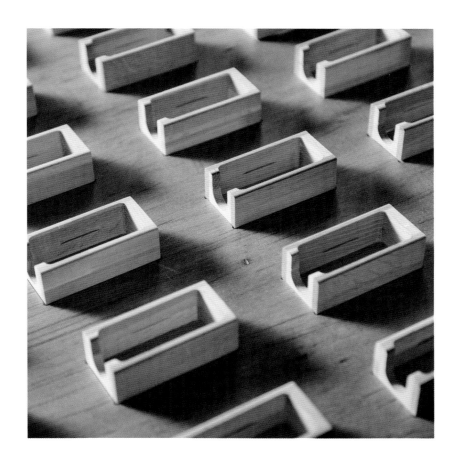

住友林業株式会社の協力のもと、森林保全活動にも積極的に取り組んでいます。木製パーツを東北地方や、北海道産のオーク（ナラ）でつくっていることをきっかけに、2021年から岩手県にある「BAUMオークの森」に毎年600本ほどを植樹しています。また、全国のBAUMストアでオーク（ナラ）の苗木を中心に育てる試みも実施。店舗で育てた苗木は、2025年以降に「BAUMオークの森」に植樹していく予定です。森のすこやかな循環をサポートしながら、将来的には育った樹木を製品に活用することを目標にしています。

地域の木材×伝統×デジタルの融合

VUILD

まれびとの家｜VUILD 株式会社

写真：太田拓実（P79上・中）/ 黒部駿人（P79下, P81上）/ VUILD（P81下）

VUILD は、デジタル技術を駆使した次世代の建築を開拓する建築集団です。ものづくりに情熱を捧げる設計者・技術者・製作者によって構成され、自社工場に導入されたデジタルファブリケーションを駆使することで、設計から部品製作まで一貫して行います。

1　課題
ISSUE

既存のバリューチェーンでは木材が長距離輸送されており、環境負荷が大きい。地域の生産者に利益が残りにくく、林業が衰退。

2　アイデア
IDEA

3D木材加工機を活用することで、木材調達から加工・建設までを半径10km圏内で完結させる。

3　デザイン
DESIGN

施主自らがデザイン、設計を行える家づくりアプリを開発。どこでも地元の木材で家を建てることを可能に。

4　展開
NEXT

さらなる技術提供を進め、「建築の民主化」を実現する。誰もが地元の木材を使い、家をつくれる未来へ。

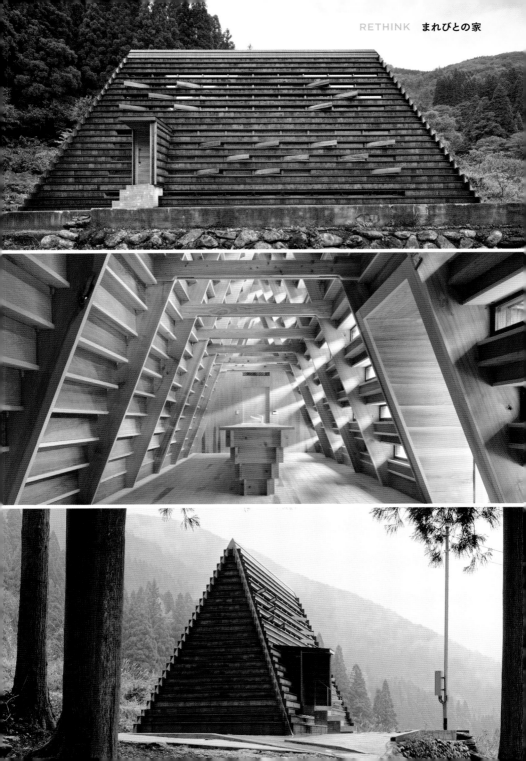

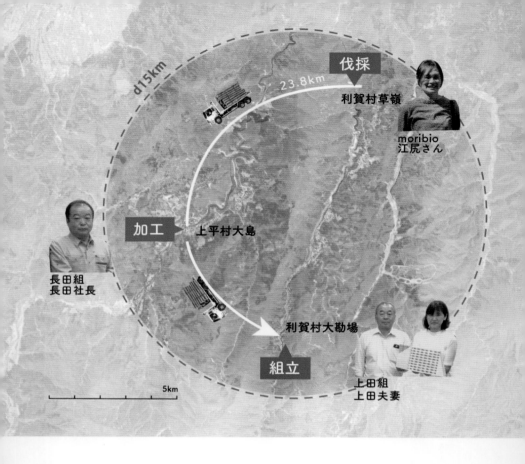

伐採
利賀村草嶺

moribio
江尻さん

加工　上平村大島

d15km

23.8km

長田組
長田社長

利賀村大勘場

組立

上田組
上田夫妻

5km

誰もが地元の木材を使い、家をつくれる未来へ

VUILD が 2019 年に手がけた「まれびとの家」は、面積の約 97％が森林に
もかかわらず林業が衰退する富山県南砺市利賀村に建てられました。3D
木材加工機「ShopBot」を使うことで、敷地周辺の未活用の木材を活用し、
加工・建設までを半径 10km 圏内で完結させることを実現しています。特徴
的なデザインは、この地域の伝統構法「合掌造り」を現代的にアップデート
したものです。クラウドファンディングの出資者同士で家を共同保有してもらう
「観光以上移住未満」の地域との関わり方を提案し、限界集落の新たな解
決策としても注目されています。

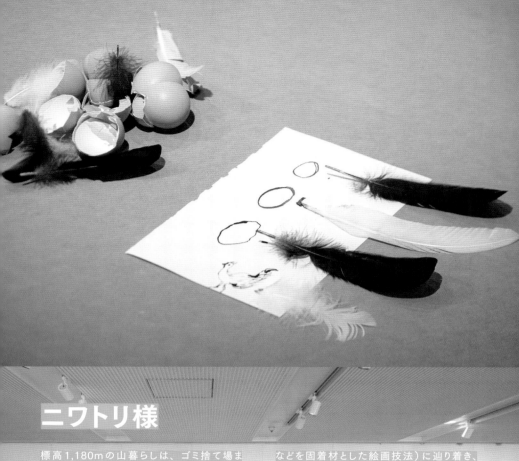

ニワトリ様

標高1,180mの山暮らしは、ゴミ捨て場まで遠い。そして出せる日も限りがあり、コンポストをしても冬場は凍ってしまう。下水処理がなくバクテリアを飼い浄化槽で処理するので、無闇に排水としては諸々を流せない。どうしても出てしまう生ごみの悩みのすべてを解決してくれたのは、ニワトリ様だ。現在30羽ほどを野放しにしている。彼らにとっての食事（残飯や野菜の使わない部分）となることと、生ごみがゼロというストレスのなさは、どれほど私を健やかにしてくれたか。そして、その恩恵としてフリーレンジの卵が頂ける有難さ。また職業柄、私は絵の具についての廃棄、つまり筆洗や残った絵の具の処理も同時に課題となった。するとテンペラ画（卵などを固着材とした絵画技法）に辿り着き、はたまた鳥の羽の筆や刷毛など私が欲しいものはこの庭にすでにあることが見えた時の感動たるや。抜け落ちた羽毛、卵の殻は私の画材となり、描く事のもっと前の段階である、その素材へ焦点を当てて制作をする事が私の役割だと思うと胸が高鳴っている。

ひがしちか
画業

2010〜2022年傘屋「コシラエル」という屋号で手描きの一点ものの日傘を制作。現在は色に関することなどを研究したり、絵本を制作。長野県八ヶ岳の山麓に住まいとアトリエを構え、創作活動を続ける。

包装紙を捨てる前に
ノートになるか
試してみた結果

コロナ禍をきっかけに、最近の私は配送をお願いすることが増えてしまった。テクノロジーがもたらす便利さと引き換えに、包装紙が山のように溜まる様子は、まるで自分の罪悪感が可視化されてるようだ。気持ちの良い部屋をキープするには、包装紙なんか、そのままゴミ箱に詰め込んで、全部捨てて無かったことにしてしまえばいい。だけど、包装紙を捨てる前に、ノートになるか試してみた。すると、罪の香りを纏った包装紙たちが、愛おしい日用品に変化した。日常の中で、目を逸らしながら、心を無にして捨ててるものは多い。捨てる前に試せることはもっともっとあるのかもしれない。

清水淳子
視覚言語研究者／インタラクションデザイナー

2009 年 多摩美術大学情報デザイン学科卒業後デザイナーに。2013 年 TokyoGraphicRecorder として議論を可視化するグラフィックレコーディングの活動と研究を開始。同年、UX デザイナーとして Yahoo! JAPAN 入社。2019 年、東京藝術大学デザイン科情報設計室にて修士課程修了。現在、多摩美術大学情報デザイン学科専任講師。視覚言語についてメディアデザインの視点から研究中。著書に『Graphic Recorder —議論を可視化するグラフィックレコーディングの教科書』(BNN 新社)。

Loop **104**

繰り返し使い、使い捨て文化から脱却する

WOTA BOX **108**

持ち運べる水再生システム

ダンボール回収システム **112**

ダンボールを店舗で回収する

繰り返し使い、
使い捨て文化から
脱却する

Loop ｜ Loop Japan 合同会社

捨てるという概念を捨てようというミッションのもと、使い捨て容器で販売されていた食品や
日用品の容器を、耐久性があり再利用可能な容器で販売することによって、ゴミを減らすこ
とができるプラットフォーム Loop の管理・運営を行うソーシャルエンタープライズ。

1 **課題**
ISSUE

使い捨てを前提としたリニアエコノミーからサー
キュラーエコノミーへと転換することで、人類の大
きな課題であるゴミ問題を解決する。

2 **アイデア**
IDEA

使い捨てにされていた商品の容器を耐久性があ
り、再利用可能な容器に替えて販売。使用後は
回収、洗浄、再充填を行う。

3 **デザイン**
DESIGN

そもそもゴミを出さないという仕組みを構築したこ
と。容器だけではなくシールや素材なども、基本
的にはリサイクル可能なものを採用。

4 **展開**
NEXT

プラットフォームをより使いやすく、また商品数を
増やして便利にすることで、ユーザー数や利用可
能地域を広げていく。

REPAIR

re·pair / ripéər

修繕する、修理する、回復する。

壊れたら直して使うこと。
あるいは直せるように仕組みやサービスでサポートすること。

iFixit 116

修理を愛する人たちがつくったあらゆるものへの修理ガイド

Fairphone 120

自分で修理ができるスマートフォン

修理を愛する人たちが
つくったあらゆるものへの
修理ガイド

❌ **IFIXIT**

iFixit

iFixitはカリフォルニア州に本社を置く、携帯電話やPC、ゲームコンソールや家電製品、衣類など約9万種類の修理ガイドを提供する世界最大の無料のオンラインコミュニティです。デバイスの寿命を伸ばすために、多岐にわたる分野の交換部品や修理に必要なツールを販売しています。分解を通して、修理に配慮したデザインや修理の難易度を分析し、所有者や修理業者に与えられた自由に修理する権利を取り戻すべく運動を広げています。

1 **課題**
ISSUE

電子廃棄物のリサイクル率はわずか20％に留まる。修理に配慮していない設計になっていたり、ユーザーに修理マニュアルや部品が提供されていない。

2 **アイデア**
IDEA

無料で修理ガイドを提供し、メーカーと連携して交換部品や精密ツールを販売することにより、「壊れたらまず修理」という選択肢を増やす。

3 **デザイン**
DESIGN

約4万4千種類のデバイスの修理ガイド、トラブルシューティング、アンサーフォーラムなどリペアコミュニティを運営。現在12カ国語に対応。

4 **展開**
NEXT

メーカーに対するリペアビリティ向上の働きかけや修理する権利の法制化を目指すなど、持続的に製品を使い続ける取り組みを推進。

長く使い続けられること。フェアであること。

Fairphoneは、オランダのスタートアップ企業によって2013年に発売されました。修理・改修が容易なモジュール式を採用していること、リサイクルされた材料でつくられていることが特徴です。同じスマートフォンを長く使うことは、E-wasteやカーボンフットプリントの削減につながります。

さらに、不要になったスマートフォンを送るとギフトカードを受け取れるリユース・リサイクルプログラムを導入。リサイクルされずに家で眠ったままのスマートフォンを、貴重な資源として循環させることを目指します。

長持ちさせること、E-wasteを削減することに加え、Fairphoneは環境・人権に配慮された素材の採用、サブサプライヤーを含めた労働条件の改善など、材料や生産過程がエシカル [P186] であることにもこだわります。

短い製品ライフサイクルで利益を上げる仕組みだった家電業界に、新たな風を吹き込んでいます。

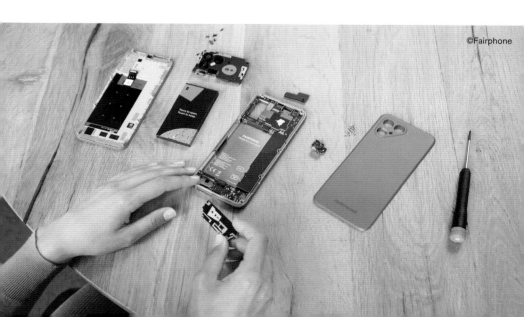

©Fairphone

Action 6

REPURPOSE

re·pur·pose / riːpə́ːrpəs

…を別の目的のために再利用する。
…を別の目的に利用するために
つくり変える。

資源として回収した後に、別の形であっても一回でも多く使えるようにすること。

株式会社モノファクトリー 　　　　140
発想はモノから生まれる

OSAKINIプロジェクト 　　　　146
リサイクルの町から世界の未来をつくる町へ

BRING 　　　　150
服のゴミを原料に変える

株式会社日本フードエコロジーセンター 　　　154
食べ物の"環"をつくる

CDプラ 　　　　158
CD・DVDから再生プラスチックをつくる

RefFプロジェクト 　　　　162
紙おむつの未来を考える

オリジナルブレンドマテリアル 　　　　166
パッケージの本質的な素材循環を目指す

お菓子袋の素材を変える 　　　　170
牛乳パックの製造工程を利用し、
アルミ蒸着袋に変わるパッケージ素材の提案

スマホ供養 　　　　172
スマートフォンを供養することでリサイクル回収率を上げる

発想は
モノから生まれる

株式会社モノファクトリー

株式会社モノファクトリーは、「循環を前提とした社会の構築」をビジョンに、様々な企業・
社会における "循環可能な" 仕組みづくりをサポート。これまでにない廃棄物の使い方の創
造を目指し、ビジネススキームの構築から、企業に保管されているモノのリユース、リサイク
ルの提案まで、各企業のパートナーとして、循環を前提とした社会の構築を目指しています。

1 課題
ISSUE

モノの一生は埋め立てられるまでを指す。循環を
前提とした社会の構築のためには、リサイクルだ
けで良いのか。

2 アイデア
IDEA

廃棄物をリサイクルのスキームに乗せることはでき
るが、その前に廃棄物自体のおもしろい形をその
まま使えないだろうか。

3 デザイン
DESIGN

廃棄物由来の「マテリアル」を通して、学び・体験・
発見の機会を提供。「すてる」から「つくる」流れ
を生み出す活動を行う。

4 展開
NEXT

捨てられた素材の情報プラットフォームを構築し、
捨てられたモノが活用されるのが当たり前の社会
を目指す。

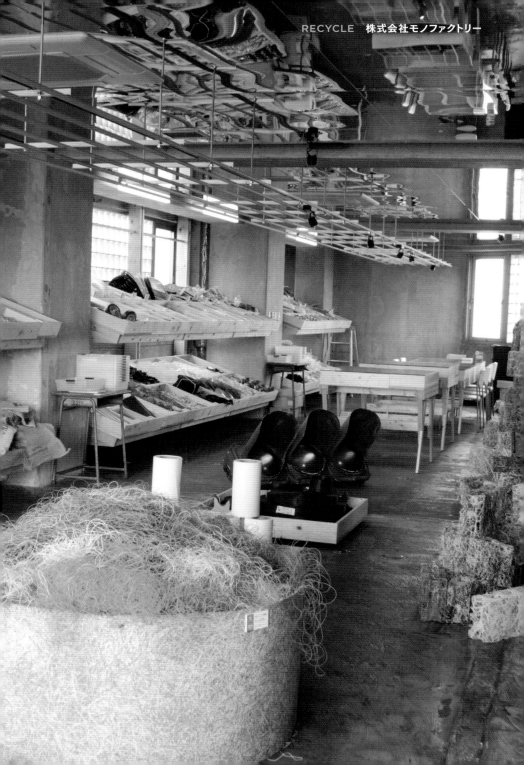

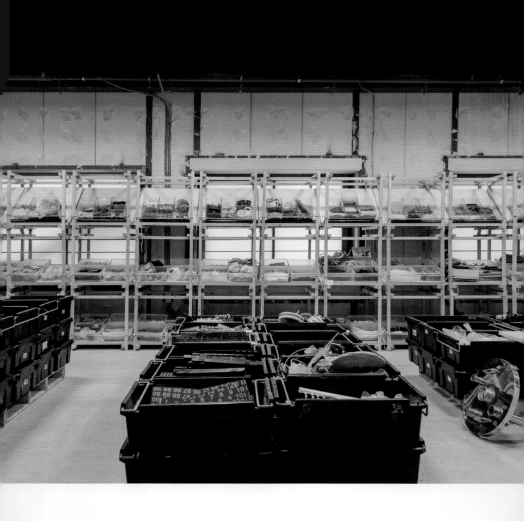

マテリアルを通した学びの提供

モノファクトリーの"マテリアルライブラリー®"には、多種多様な廃棄物由来の「マテリアル」が並んでいますが、多くの人が触れたことのないモノばかりです。モノファクトリーでは、これらのマテリアルを通して、不要になって排出される様々なストーリーや廃棄物の魅力を伝える講義やワークショップ、自社工場見学などに積極的に取り組み、学びの機会を提供しています。

コンポストで始まる循環の生活実装デザイン　　176

「生ごみ削減を手軽に、楽しく」を後押しする

鴨志田農園　　　　　　　　　　　　　　　　180

地域の20km圏内の循環を設計する

「生ごみ削減を手軽に、楽しく」を後押しする

The Orangepage Inc.

みなとーく

コンポストで始まる循環の生活実装デザイン
株式会社オレンジページ、ローカルフードサイクリング株式会社、みなとーく

写真：ローカルフードサイクリング株式会社（P177, P178）

「コンポストで始まる循環の生活実装デザイン」は、オレンジページのブランドパーパス〈「食」を起点に暮らしをつくり、生活者、コミュニティ、地球のよりウェルビーイングな未来をつくる〉に基づき、バッグ型の「LFCコンポスト」を開発・販売するローカルフードサイクリングと、東京都港区においてまちのコミュニティと地域の未来を考える「みなとーく」と連携し、「都市で生ごみを捨てないコンポストのある暮らし」を生活実装させるプロジェクトです。2021年度グッドデザイン賞受賞。

1 課題
ISSUE

生ごみの約80%は水分といわれ、ほとんどが焼却処分され、多くのエネルギーと税金が使われている。

2 アイデア
IDEA

生ごみを資源化するコンポストをライフスタイルとして広く定着させることで、生ごみ焼却ゼロの実現を目指す。

3 デザイン
DESIGN

都市生活者も取り入れやすいバッグ型の「LFCコンポスト」を用い、多面的アプローチで生ごみを循環させる暮らしを提案。

4 展開
NEXT

コミュニティコンポストの社会実験などを通し「コンポストで始まる循環の生活実装デザイン」の輪を広げる。